UMBILICAL

HOSPITAL

UMBILICAL
HOSPITAL

vi khi nao

1913 Press

www.1913press.org

1913press@gmail.com

Umbilical Hospital by Vi Khi Nao ©2017

1913 is a not-for-profit collective. Contributions to 1913 Press may be tax-deductible.

Manufactured in the oldest country in the world, The United States of America.

Many thanks to all the artists, from this century and the last, who made this project possible.

Founder & Editrice: Sandra Doller

Vice-Editor: Ben Doller

Managing Editrixes: Adam Stutz & Adam Bishop

Editrix Team: Biswamit Dwibedy, Brianna Johnson, Emily Mernin, Yesenia Padilla, Leslie Patron

Text and cover design: This Common Place

Cover art: Heide Davis

ISBN: 978-0-9990049-2-0

for baby Alphie

TABLE OF CONTENTS

UMBILICAL

HOSPITAL

[**Umbilical Hospital** *is a poetic ekphrasis of Leslie Thornton's "Sheep Machine," part of her Binocular Series. Filmed in Saas-Fee, it shows a flock of sheep grazing next to the structural support of cable car system. Leslie Thornton views her video installation as film paintings.*]

YOUR CLITORIS IS GONE

You are an alien wearing a sheep-asshole hat &
candlelight pokes out from the softest ether &
your eyes are born out of sheep pasterns & you
are wearing a contour mask for the wyes & the
clitoris is gone. Your clitoris is gone, disappeared
probably in your butt crack, or perhaps it has
grown smaller, smaller than a pearl. Your face &
smile are grim as the night. There is a window
on your forehead that leads through the
mountain. You can see the landscape there. &
you multiply yourself five times. What are you?
Then? If not a sheep machine?

YOU WALK AROUND A LAKE WAITING FOR A STAR TO ADOPT YOU

You walk around a lake, waiting for a star to
adopt you. & when it appears, to adopt you,
that is, you can feel the five seeds of infinity gaze
back at you with their burly tongues, hanging
down like those werewolf dogs, hyphenating
their salivating panting & you think it's
possible for you to hyperventilate now. All five
dogs wearing insignificant crowns, betraying the
heat of the ontological question: Am I still alive?
You take each one aside to question the source
of its exhaustion. Does infinity behave like a
dog? Panting? Hyperventilating? You do not
know your infinite circles of darkness.

WHILE EVERYTHING BECOMES SYMMETRICAL

While everything becomes symmetrical. The
lake. The sky. I climb over the hills without you.
I climb over the hills with you.

MAKE YOUR UNKNOWN KNOWN BY WALKING AWAY

Make your unknown known by walking away.
Two moons sit side by side like owl's eyes. Not
glancing. Not looking. Not blinking. Just staring.
Courage & wisdom: these are essential wheat,
daily bread of air & time. You advised the
moon owl: If you stare enough, a pastoral field
will unite a lake like marriage made inside a
concubine's hairdo.

TO RELINQUISH OR TO RELEASE

To give the cosmic lake the ripple effect of sound and to amplify its existence, the wheat, shuffled around by the wind, willingly or unwillingly volunteers for the task at hand. Blooming like the smallest mushroom cloud, the wheat arches its back & awaits the invoice of time to relinquish or to release.

IS IT POSSIBLE? DOES IT SEEM?

Is it possible? Does it seem? Five scrawny
Egyptian drag queens are wearing dark garden
oasis dresses with matching headdresses, their
five pairs of twiggy, spiderlike legs dangling out.
The five queens are united at the pelvic bones by
the pentagonal structure floating on the cosmic
bed. Are they swimming or are they recumbent,
getting their annual avocado-colored tan? Sheep
cluster together like dandelions. Wheat in the
wind. Wheat & other combinations of life.

YOU ASK POETRY TO LIVE BY ITSELF IN THE WOOD

You expect nothing to happen, but something
has already happened. You ask poetry to live by
itself in the wood. You ask politely. Very
politely. Maybe out of pride & rigor. &
then, an array of wheat shows up, blurring the
line between blondness & sheep's wool. &
naturally, the web of spiders keeps you in the
wood. You keep yourself there until you break
apart like twigs.

HEADS BOW LIKE AN OX

Enervated with being one, the sheep separates, multiplying into two or three pieces of prostrating pastoral masticators. Heads bow like an ox. & time flies like wheat in the wind, bending only for the weight of gravity & for darkness to fall. Even the earth, strong as she is, can't cry on the sleeves of tomorrow. Today, the earth gets carried away with the meaning of sheep stepping on her back, feeling the pressure like needles inside a pincushion. Today, the wind might cry into the pockets of pollination and mourn the misfortune of being born into another day, which is another lifetime.

THE EARTH LIKES TO WEAR A SHIRT

The arrows of desire cast the biggest shadow on
the cosmic lake's floor. & their aim is
uncommon & invisible like the taut skin of
god. You must forgive the way landscape unfolds
or creates its own symmetry of want. Meanwhile
one sheep blends into the flock of sheep – not to
keep warm – as it appears to be summer. Just to
ascertain the magic of being able to blend with
anything, including itself. The earth likes to wear
a shirt not written in distance but in time. At
times, your gaze must bend backward to see
something else. Something not yours &
something that does not belong to the landscape
or the gaze either.

WHAT CAN YOU DO?

Chaotic lines sleeping beneath chaotic desires –
sleeping together on a hammock made of two
eyes, singing earthly & cosmic lullabies to
themselves. What can you do? What can you
do? But either open your eyes or close them too.

PASTERNS

What if – as a hobby – you were a sheep. In order for you to create camaraderie with your fellow sheep, you would give each other high fives by pressing your pasterns together. You may find the gesture comedic, but in fact it brings symmetry to the work force!

THE IMPOSSIBLE HAS IDENTIFIED ITSELF

The impossible has identified itself. A star made of wheat stitched through the five assholes of the clitoris-satisfied sheep, holding itself stationary, solid in time. & more importantly five frogs birth themselves beneath each armpit of the star. Five grim frogs, whose eyes have lived or burrowed on the sheep's hind legs. To hold the image together, the star carves its texture & existence into the consciousness, the content of the cosmos. Look & relook: the threading is a paradox: skillful & seamless. Has the esoteric thing been born from the imagination of God or from the image of chance? Is God chance?

GOD HAS AN ARCHIVE OF CANCER CELLS

God has an archive of cancer cells he uses on
humans when he is bored. Is he bored here?
Inviting a skeleton to dine on the pastoral table
of grass? We bite & remove the horseshoe-
shaped lips & kiss the engine of melancholy
away. We are certain we have been cheated out
of 4.3 years of our lives. We talk about dividing
our flesh before releasing our breath &
evacuating our blood. But God is busy escorting
a flurry of sheep towards a moistureless river
where the sheep take small drinks of air &
collapse when a mirage of thirst sweeps across
the landscape.

GENOCIDE BY THE LAWNMOWER

Do you wonder if amongst the million heads of grass – each blade twirling in the wind – one blade of grass ever turns to another to wish it peace & prosperity? Or does a grass ponder if its skin is greener than its neighbor? But if 4.5 million blades were to experience genocide by the lawnmower, do you think their god would resemble something like the two gravitationally savvy thighs of the sheep before us? It is unspeakable to speak of redemption when everything is dying.

BENDING OVER YOU THINK YOUR LIFE IS OVER

Bending over, you think your life is over. Even a
mask with scary teeth won't prevent you from
licking your own sorrow. Even the earth can't
hold your mouth down & your chin disappears
into soil. Even the legs of sheep can't
misconstrue your existence for something else.
You sneer & then you move forward.

WHEN THE NIGHT DROPS HER BLACK UNDERWEAR DOWN YOUR SOUL

When the night drops her black underwear
down your soul – the spiders are busy screaming
their matrix of light & threading their web of
lies. You are here, suspended between the ether
of profanity & the ether of sanctity. & you
gaze closely between the cracks of the sheep's
evanescent existence as the dusk of light does not
fall as you expect it to fall. Some corpulent frog
with its lips sealed by the spiders' webs of lies is
eyeing you in utter contempt. You are here &
then you are no more. Lips whisper lips,
landlocked by sound & image & ennui.

SONIC TITILLATION

Raining doubt. Raining sheep. Raining twirls of
memory. So an arc of wheat hovers over the
bodice of sheep like a crown & then the
voluptuous asshole & its voluptuous clitoris
gain some suspended gravitational momentum:
such are the eyes of the silenced bunny-frog
doomed for sonic titillation. We are here & we
are clueless about wheat-shaped eyes &
eyelashes with angelic hovering crowns. & so
we rotate our clitorises in circles. Maybe even in
semi-dictatorial circles. Our pleasure is not a clock.

AFFLUENT CUM

Scintillating asshole shimmering brightly like the
North Star & what about the hybrid between a
grassbunny & a frog? Is it round & fat? &
circular? What about the clitoris of the sheep
that drips with affluent cum? What about the
baseball-field-shaped nose of the bunny-frog?
What about this cavernous road limned by
chalk?

NO CHANCE OF RETALIATION

More than the benefit of reaping the rewards of
grass & frogs & double visions or double eyes
and the sanctuary assembly line of assholes is the
benefit of sheep heads & their ability to
become vacuum cleaners. They suck the grass
into their mouths. They blow their desires
back out. We are, of course, doomed & have no
chance of retaliation.

VULGAR ACT OF HOSPITALITY

The entrance into the ass threshold is erected like a monumental curtain. The solid fabric of the threshold is the color of light wheat & won't flap in the wind & its minimal promenade of wheat is designed to welcome visitors into its sovereign asshole. There is something sacred about this vulgar act of hospitality. Even at the footing of this ass-temple are two eyes. While one gesture invites, the other repudiates, sending mixed signals like a schizophrenic.

THIS IMAGE IS PROFANE

This image is profane. It is a chicken displaying its vaginal entrance to the viewers while bending over, head to the ground, chicken legs spread. The vaginal entrance of the sheep-chicken is extraordinary in the sense that it has two vaginal thresholds. This is fairly impressive, considering that most have only one. Does it appear morbid? This vulgarity? Or is it entertaining? Meanwhile, is that a dog?

HOSTIA VAULT

What would you do if you had an asshole in a jewelry vault the size of a hostia vault? & what if sitting beneath that fault were an elderly elf in transparency? & what if sitting beneath this tiered layer of transparency were another elf wearing bat wings & whose v-shaped chin was coruscating like an arrow of light? & what if, amongst all of this mythological mysticism, the armless shoulders of a sheep were standing in ontological temptation of its scrawny winged existence: the standing-posture-of-a-human sheep is thinking: how can I fly when my wings are made of four skinny blades of wheat, one on each side?

FESTIVAL OF DELUSION

More or less the sheep-windmill structure has
bestowed on the grass a crown made of thorny
wheat & a circle of emptiness so the nose of
the windmill can sniff, can inhale, can partake in
the afternoon grass smelling contest. Join in the
festival of delusion. & the illusion of having
been born in the wrong kind of olfactory
century.

YOUR PURITY CAN CONDEMN YOU

You think your divinity can turn its sexy back on
you, wings folding inside as if to conceal flight,
but the bulbous tailbone of your existence ends
up betraying you. Five of you turning like so, like
angel machines in the afternoon light. Even in
this light, your purity can condemn you &
parts of you will never forgive the cosmos for
bowing its angelic head as if it had been
decapitated by incorruptibility.

THE BATTLE OF THE GAZE

Third leg must be invisible; there is no other way. Tripodic windmill with alien face wears a hay mask. Stands before the viewers, waiting for the battle of the gaze. Is there simile in this discontinuity: between man & man's perception of reality? Surely, all the sheep bending over the grass aren't just performing a purely chthonic task of facial burial. The funereal eating task. & so on & so forth.

SAY IF YOUR ASSHOLE IS CANCELLED OUT

Say, if your asshole is cancelled out by the semi-
equal signs of hay-based clitoris, what will you
do? For instance, the bunny's eyeballs are much
scarier now. & the bunny's lips may be much
grimmer. These are graphic symbols that may
suggest pentagonal movement. The hills &
valleys of the sheep's butt cheeks are deliberately
round, rounder than one's knowledge of
roundness & more than round, they are
sacrosanct. In this trinity of focus between the
sheep, bunny & frog lies the consecrated
clitoris which can be seen as the Roman
Catholic unleavened host in which the tips of the
tongues may find their pleasure vault.

UMBILICAL HOSPITAL

The windmills have been converted into nefarious ants who are doing handstands with their heads between their legs, staring straight into the viewers' eyes. The ants do not appear here to create an amicable relationship. They have landed on earth as predators, using the windmills as hosts like parasites using your body as their umbilical hospital.

INVERTED V

You can't spend all day speculating about the
essence of a smile or what it can do for you on
your off day, but gazing into the mouth of the
windmill, perhaps you can spend all day making
grandiose speculative gestures & the net of
illusion will come along trapping you in its
matrix of nothingness. So, the windmill is giving
a mean, roaring gaze to the diminutive inverted
V, threatening it for combat. & so. & so.

THERE IS MORE THAN ONE WAY TO ENTER THE THEATER

The sheep, the creative geniuses of stationary cinema, have transformed & carved their egg-shaped windmill into a small Shakespearean theatre. The truth is: Hamlet won't be able to perform his familial heartache or revenge here. Meanwhile, all types of wheat flags are flying on the sea of wool, creating a beautiful chaos of pastoral noise. There is more than one way to enter the theater. Through symmetry or through incandescent rituals such as eating or being bored out of one's wits.

HYBRID BETWEEN BACON & WOOL

Perhaps wanting to be smart, the sheep beg to
be converted into pigsheep, the hybrid between
bacon & wool, natural intelligent resources.
These pigs also don wheat-whiskers & live a
life with their pig-sheep tails turned away from
the Venerated Monuments: queens of some sort
wearing an infantile regal dress. The queen, in
general, is flanked by two fairy queen Persian
dudes, dressed for devotion & submersion.
Who would be snorting at such a sacred palace?

BLOND & GENTLE

At what station in your life are you clawing your
way through the V-shaped threshold of the
pleasure point? & as your sheep body twists its
way into a boxer's grip: do you wonder where
you were born? Or what brought you here?
How have you bifurcated or multiplied your
frame of existence? How do you expect me to
love you? As parts of you scatter, as parts of you
conform, your pastoral noses to the pastoral
ground. Blond & gentle, the wind blushes.

MOST OF ALL YOU DIDN'T EXPECT THE SHADOWS TO BECOME GODS

Most of all you didn't expect the shadows to
become gods, converting the voluptuous shapes
of sheep into skeletal edifices. But here they are
now, appearing as post-carcass structures &
altering the egg-shaped windmills. Here the back
view of the windmill has been carved with
Halloween will: ghastly eyes, ghastly elongated
nose, a ghastly smile showing all perfectly
aligned teeth, & a disembodied body holding
up a veil-less veil, transparent & tied to the
meditative landscape of the cosmos. The
windmill has been shortened to just a head.
Imagine that? Imagine losing your pliable legs.
Imagine standing on your head. Imagine smiling
the way ghosts do.

TO EAT IS TO NOT KNOW

In order to spread its wings, the egg-shaped windmill stands straight on its pre-collapsible legs & confronts the cosmic lake world. The heaven has been mowed & is smooth like a newborn field of dreams. Will this egg fly? On the other side, bending as in preparing to be guillotined, the sheep masticate. To eat is to escape looking ahead. To eat is to block out the world. To eat is to not know. Consciousness folding back into itself.

MANY ARE AFRAID

You don't want the frame to the entryway to be melodramatic, but it is, drooping its hay-colored mustache & giving you the meltdown of a sadness. You don't expect to win in this type of war. And, regardless, a mouth is a dangerous orifice for entry. Many are afraid to enter despite some mouths possessing no teeth.

YOU ARE SITTING ON AN EGG CHAIR

You expect all of your exit points to be framed by an inverted V-shape structure & you expect all of your desires to walk in & out of you like the great monsoon. Soon, there will be nothing but you, standing like the windmill with legs apart as you contemplate your existential eggness. You are crackable; this you have already known. & as your exit points tell you, instead of standing on your thin legs as others have misread you, you are sitting on an egg chair.

ISAAC'S SACRIFICE

To plow ahead while ingesting seeds of dismay;
long tongues lolling over friable threads, thin
hills undulating & wet as in swallow as in it's
never too late to clasp, to shut the mechanical
corridors of the mouth. They walk slowly, heads
bowed sometimes below the waist, necks
exposed in reverse like Isaac's body ready for the
ultimate sacrifice. No one knows this more than
God, not even Isaac, who has to offer the lamb
on Abraham's behalf. God made the ultimate
sacrifice, by walking away, not falling through
with the ax – knowing Abraham would not
make the sacrifice, the sacrifice of not axing his
son. Knowing that Abraham would betray by
being faithful.

THIS IS THE EDGE

To love the earth more than to love the edge of sleep & to love each equal in distance is to love certainty more than to love the surrendering of certainty. This is the edge. The windmill, dome shaped now, more now than ever, has turned its back towards residuum. What have you turned your back on lately? What have you betrayed?

SULTRY

If a sultry lazy chair is placed inside of the semi-transparent dusk-exuding coffin, would you sit down on that chair & cough? Or recline while the ovoid windmill sits beneath its own web-invented dome? What will you do? If the back of you exhibit a fancy set of Halloween teeth?

EVERY NOW & THEN YOU DISCOVER

THE CLITORIS HAS SUPERPOWERS

Every now & then, you discover the
clitoris has superpowers: the ability to lift itself
up to expose its pleasure threshold & more
than that, the ability to create another hole small
enough for a white bullet to pass through
without creating any internal damage. And, of
course, beyond the sheep's ability to transform
itself into knuckles & digits, the standing
feminine sheep is standing, gripping dark matter
into her being. We are little suspended by these
unexpected acts of beauty.

TWO COFFINS FOLLOW ONE ANOTHER HOME

If the windmill insect is using its intellectual mirror to lengthen its legs, then the music of transcendence, of crossing one plane of reality into another plane is guided to the edge of cosmic knowledge. Two coffins follow each other bumper to bumper, carrying the coruscating cinemas of landscape with them as they dangle in the ether. Watching over the bowing bodies of the sheep, they realize that to look up is to see moving clouds, to gaze down is also to see moving wool-shaped clouds. In the world, where the portable coffins are the middle people, the transference from life to death & from upper to lower is just another form of banal euphoria.

RELIGIOUS CONVERSION

The congregation of windmills has made a
religious conversion. It has decided to become
an Easter egg. It sits on its diminutive triangular
camping chair & turns its back on the world.

TO ACCEPT DARKNESS OR TO ACCEPT LIGHT

To accept darkness or to accept light: no
permission is necessary in these parcels of
extremity. Still the wheat hovers over the
windmill like an angel while a semi-translucent
spaceship descends its throat. The angel wearing
the garment of wheat separates the spaceship
from itself & the spaceship from the windmill,
whose reflection on the grass is like a lake. The
windmill has a shadow & a will & on the
lake made of grass, it dines on a bed of valley like
lava on a crater.

FIVE BLACK DIAMONDS WANT TO BECOME PHILOSOPHERS

Five black diamonds want to become
philosophers but can't become philosophers.
Five black diamonds sit at the pentagonal cosmic
poker table. Five gamblers made of soil &
wheat sit at the table, waiting to make a bet.
They will be betting on who bluffs best, who
amongst them can conceal their fat fate best.
They all want to be Phil Ivey. They all want to
stare well & win.

I PROFESS I KNOW NOTHING MORE

Five bug-shaped coffins with the letter "V"
tattooed on their backs sprouted a pair of skinny
black legs so stalwartly, one has no choice but to
consider their companion: a spiderweb of lies
and elevation. & like anything else in life: view
the momentum of change & ride on it. When
it's too high, get off. At times when a coffin
ascends & the butt cheeks of sheep are no
longer butt cheeks but geometrical figures in
bucolic space, it's time to question. To restitch
the hemline of one's profession. I profess: I know
nothing more about the altitude of my butthole.
I promise to split in half, to spread-eagle, to alter
the delirium of grass. Smell the aroma of
wholeness. Smell, dear readers. Smell.

IF EARTH & MACHINE COULD EXPERIENCE TELEPATHY

If Earth & Machine could experience
telepathy, it would be at this moment: this
intersection of coffin & the poignant balance of
wheat. Such crispness in the arrow of desire as it
is a tool/an art object/a procreative instrument
that simultaneously opens & penetrates. When
the earth surrenders her cosmos of oblivion, the
coffin ascends, cable to cable while a blurry
sheep with the smallest eye in the world –
a keyhole – gazes on, perhaps not
contemplatively because it is just a ball of wool.

BEAUTY ASSERTS HER MATRIX

The aesthetic matrix of the cosmic lake is also an intellectual matrix: wheat crisscrossing, spread eagle their inner thighs & earth is not flat & grass deceives a little, competing with wheat to see who spreads their prostituted legs the widest. We gaze, finding our innocence in the sheep, but a funeral will come for our sexuality, killing our appetite for sex & intellect. Beauty asserts her matrix, inviting spaceships to re-enter their force of field. The penetration lies in our gaze, but also in our lack of distance. In our inability to discern when to enter & when not to enter.

ELEVATED & FRAGILE

More than the arrows of suspension are the
arrows of penetration. Wings of wheat, arms
spread apart, elevated & fragile, waiting for
the opportunity to pierce the crisp, gravitational
forces separating one plane of reality from
another. Within their own magnetic field, the
thresholds of the abysses exhibit their own law of
gravity & open themselves for the suction
opportunity. Meanwhile the funeral heads have
appeared & have returned to their own
airbase. & meanwhile scattered sheep,
scattered wheat, experience the external turmoil
of the cosmos.

VERDANT SWARD

The 13th letter of the alphabet appears in the form of a spiderwheat: a potentially friable spider whose biological structure (DNA & RNA) is primarily made out of Demeter's essence. & the 13th letter of the alphabet wishes to kiss the diminutive, grass-based 22nd letter, V, while gazing in its reflection in the mirror of the verdant sward. Will it succeed in its lustful endeavor?

IF A SHEEP BECOMES A LAKE OR A STONE

If a sheep becomes a lake or a stone, will you ask
it to be your tombstone? Sometimes when your
tombstone walks away to eat grass & fodder
and fart, will you be able to live with yourself?
Dying this way? Through mastication.
Sometimes when your lake ripples outward &
absorbs everything like a large mouth – would it
be able to take anything? From you? Just think
about this. This lake. Your wooly tombstone.
This bald being, not so bald? Would you go on?

ARROW OF WHEAT

The sheep splits its body, its clitoris, its window
of desire in half so you can be that wheat stick
figure in the breeze, as you contemplate walking
through it. You don't know if you are walking
through the threshold of desire or what world
this is. You are so small & your ability to
inhale pleasure may not be as large or
prodigious. Even before the gate of pleasure,
there is a gate, a rail made of electricity, made to
prevent you from entering. You will be shocked.
And then you will live. Two pieces of dentures
flank your entrance. You ignore. You proceed.
The only thing keeping you back is your
pleasure. Even that you haven't surrendered. A
point will drill the arrow of wheat into your
asshole – but this will come later.

PROTECTED UNDER THE SOFT COTTONLIKE ARCS

Protected under the soft cotton-like arcs, the
wheat pinchers display their valiance like arrows
before a bow. They intend to aim & to deliver.
In their suspension, they feel they serve their
purpose. & without releasing, they
acknowledge that below, the clouds in the form
of sheep do roam like large bald stones.

THE NIGHT CLEANS HER BLACK TONGUE
WITH THE SLEEVES OF MY HEART

The night cleans her black tongue with the
sleeves of my heart, licking the darkness here
and there. My soul. Like a dog. Upon my soul.
The visitation takes place. Sheep pile on the
grass like blond garbage bags. Any moment – to
be toppled over. At any moment. The wind
greets the afternoon. Shadows cast on the cosmic
walls. Tiny specter of uniformity. Tiny specter of
death. I like to open my eyes & ears to the
swollen afternoon. I would like this & then I
would like the sheep to spill their guts. I want
this to continue on.

SIAMESE SHEEP

Seamlessly, as if the landscape attempted to fall
into itself, homogenizing the skin of landscape
with the skin of wheat, this blanket of
surrendering, one sheep falls into the body of
another sheep, becoming one. So then it's
difficult to distinguish, whose stomach belongs to
whom & if this is a sudden romance of
Siamese sheep, one wooly body sharing two
sheep heads. When landscape marries itself to
itself, the only infant borne out of this nuptial
narcissistic love is a muted cosmic lake,
bestowing no illusion of a ripple.

FLORAL CAVES

The breeze hasn't changed the course of blades
of wheat, but chaos it has inspired in the empty
hearts of its grain. Time pulls seeds out of their
floral caves & induces a whole population of
pollination. You can see the havoc in the grass
seabed, twining & intertwining.

NEW CURRENCY

The currency of reality is not made from yen or from euros or from any monetary value that we know of. The flat, round earth is crispy, newly made from the printer of the camera's gaze, meant to purchase ontology, pastoral peace, & perhaps a coffin that properly delivers the dead old currency to the new currency. Two sheep huddle, headless to our view, & discuss the percentage of facial expression in the new currency. Meanwhile, on the other side of the coin, no king or prime minister has appeared yet to make its landscape more valuable. The cosmic lake in the shape of the cosmic coin is as silent as bone marrow.

TWO SHEEP IN A SEMI-WHEATBUSH

Two sheep in a semi-wheatbush, blushing
secretly to themselves while a coffin ascends &
descends like a black, wingless sarcophagal bird.
This time of year, nothing is possible. Not the
wind. Not the grain in & outside of time. Not
the delirium of midday mastication.

EATING ITSELF

The black pig, stationed in another plane of
time, has retreated into the mouth of the coffin's
tinted window, reflecting now instead the metal
spines of the rapid-fire tower. As the coffin
escorts itself down, the population of sheep
multiplies by two. Blades of wheat, stern in the
wind. It seems anything can happen: the
landscape eating itself, for instance.

SLEEP CEASES TO EVOLVE

The closer your gaze falls on the backside of the coffin, the higher the population of your goose bumps. The way shadow plays with itself, touching itself inappropriately in broad daylight, creates the blackest, most deformed, eyeless pig ever manufactured in creation. You have to step back from the light & pulverize a little, in order to survive the chemical imbalance of your gaze, your unexpected hallucination, & the chemical imbalance of the landscape. Sleep ceases to evolve, moving lightly in the breeze, but you wouldn't notice. The high population of goose bumps move in V-shaped patterns from your arms up to your neckline. Your hair stands straight up as if it had been militarized. The materiality of this binocular world hasn't altered your perception of the innocent specter. It could appear anywhere, on the surface of a coffin,

exploding into black wings when you least
expect. Meanwhile your gaze swims on the
surface of the cosmic lake. Your goose bumps
can deflate their terror valves. Exhale a little. As
if to become unfriendly with Sylvia Plath's
friend, carbon monoxide.

PETITE DEPRESSION

You can see the five black vectors, that star,
submerging & camouflaging the bottom of the
cosmic lake. You can see the fragility of its
concealment & you can see the fragility of the
wheat too. Will it swim out of the thin cake of
itself, that cosmic mud, like a tadpole?
Meanwhile orderly chaos reigns & now that
the coffin wins the height contest, the wheat does
not weep. Instead, it stands like a sylph, dancing
like a nude wheat figure in the bright descending
afternoon. Coffin continues to advance. &
while the blades of grass & wheat still face
westward, their zealous verve has deflated a
little. Light enough to feel their small, petite
depression.

YOU WAIT UNTIL EACH BLADE OF GRASS UNDERSTANDS THE OTHER

You wait until each blade of grass understands
the other. You wait & you wait & a part of
you wants to unwait. But you proceed like any
mammal. You emulate the gentle footsteps of
the sheep, pausing to bow deeper into the earth.
The sky remains gray. Except inside, you feel a
little dead. A little repetitious. A little religious. A
little of something. In celebration of this
phlegmatic moment, five androgynous creatures
with dresses & faces camouflaged like the
ghastly mouths of Rosencrantz & Guildenstern
pinecone your soul with their appearance.

ALONG THE FRINGE

The way wheat is blowing in the breeze one has
the sense that the wheat & the breeze are not
infants. They do not crawl along the fringe of
existence or inside existence as if these were their
first footsteps. But they are aware of the stillness
between each breath that separates the identity
of breeze & wheat. They crawl without
crawling along the fringe.

PASTORAL LULLABY

Each blade of grass swims with the delusion that
it has been through the comb of the wind &
that to be in that swing of momentum, to be that
blade of grass, is to have a micro place in the
cosmos. No matter how minor the role, it is here
to swing its soul back & forth – to rock the
earth to sleep with its pastoral lullaby.

TIME TO BRING OUT A COMB, SAYS INFINITY

Little movement. & the wind. & the
window of the star opens up her different realms
of coexisting with humans. Five aliens made
from the texture of wool sit in a pentagonal
circle, arms linked, heads linked, stomachs
linked, while wearing headdresses, all five, the
size of planets. Time to bring out a comb. Time
to bring out a comb, says Infinity.

about the author

VI KHI NAO was born in Long Khanh, Vietnam. She is the author, most recently, of the story collection *A Brief Alphabet of Torture*, which won FC2's Ronald Sukenick Innovative Fiction Prize in 2016, the novel *Fish in Exile* (Coffee House Press, 2016), & the poetry collection *The Old Philosopher*, which won the Nightboat Books Prize for Poetry in 2014. She holds an MFA in fiction from Brown University, where she received the John Hawkes & Feldman Prizes in fiction & the Kim Ann Arstark Memorial Award in poetry.

acknowledgments

Poems in these pages have appeared in: *Plinth*, *The Elephants*, & *Elderly*.

The author wishes to thank Heide Davis for the cover art & Andrew Wessels for the book layout & his cover design.

This book isn't possible without Sandra Doller, Ben Doller, Adam Stutz, & the wonderful staff at 1913.

titles from 1913 press

Umbilical Hospital by Vi Khi Nao

Playing Monster :: Seiche by Diana Arterian (Editrixes' Pick)

Dreaming of Ramadi in Detroit by Aisha Sabatini Sloan (selected by Maggie Nelson, 2017)

A Turkish Dictionary by Andrew Wessels (Editrixes' Pick, 2017)

More Plays On Please by Chet Weiner (Assless Chaps, 2016)

Gray Market by Krystal Languell (2016)

I, Too, Dislike It by Mia You (Editrice's Pick, 2016)

Arcane Rituals from the Future by Leif Haven (selected by Claudia Rankine, 2016)

Unlikely Conditions by Cynthia Arrieu-King & Hillary Gravendyk (2016)

Abra by Amaranth Borsuk & Kate Durbin (2016)

Pomme & Granite by Sarah Riggs (2015)

Untimely Death is Driven Out Beyond the Horizon by Brenda Iijima (2015)

Full Moon Hawk Application by CA Conrad (Assless Chaps, 2014)

Big House/Disclosure by Mendi & Keith Obadike (2014)

Four Electric Ghosts by Mendi & Keith Obadike (2014)

O Human Microphone by Scott McFarland (selected by Rae Armantrout, 2014)

Kala Pani by Monica Mody (2013)

Bravura Cool bu Jane Lewty (selected by Fanny Howe, 2012)

The Transfer Tree by Karena Youtz (2012)

Conversities by Dan Beachy-Quick & Srikanth Reddy (2012)

Home/Birth: A Poemic by Arielle Greenberg & Rachel Zucker (2011)

Wonderbender by Diane Wald (2011)

Ozalid by Biswamit Dwibedy (2010)

Sightings by Shin Yu Pai (2007)

Seismosis by John Keene & Christopher Stackhouse (2006)

Read 1-6, an annual anthology of inter-translation, Sarah Riggs & Cole Swensen, eds.

1913 a journal of forms, Issues 1-6, Sandra Doller, ed.

& forthcoming

Strong Suits, Brad Flis

On Some HispanoLuso Miniaturists by Mark Faunlagui (selected by Ruth Ellen Kocher)

x/she: stardraped by Laura Vena (selected by John Keene)

Lucy 72 by Ronaldo V. Wilson

Old Cat Lady: A Love Story in Possibilities by Lily Hoang

Conversations Over Stolen Food by Jon Cotner & Andy Fitch

Hg, the liquid by Ward Tietz

1913 titles are distributed by Small Press Distribution: www.spdbooks.org